■ Fruit

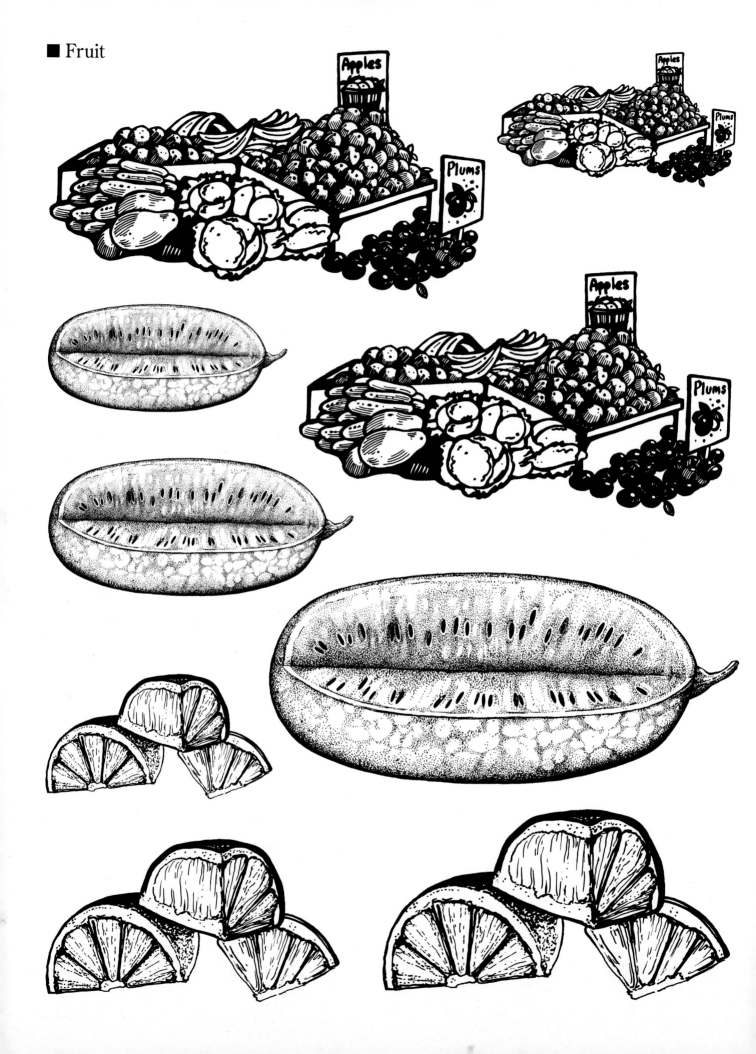

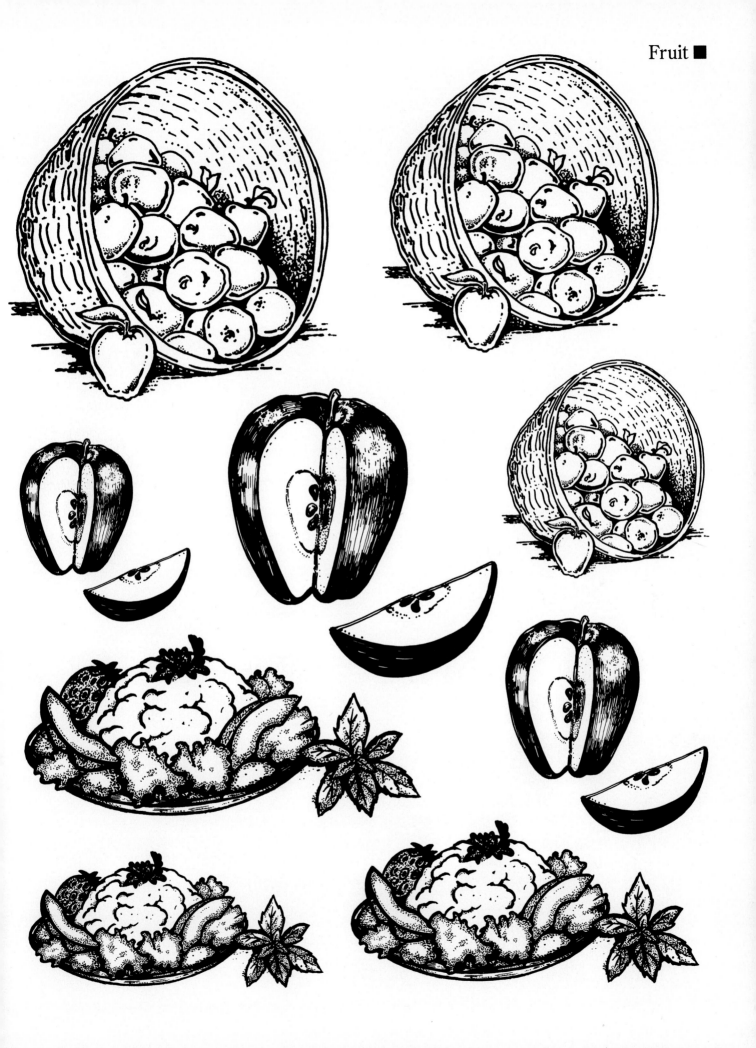

■ Fruit

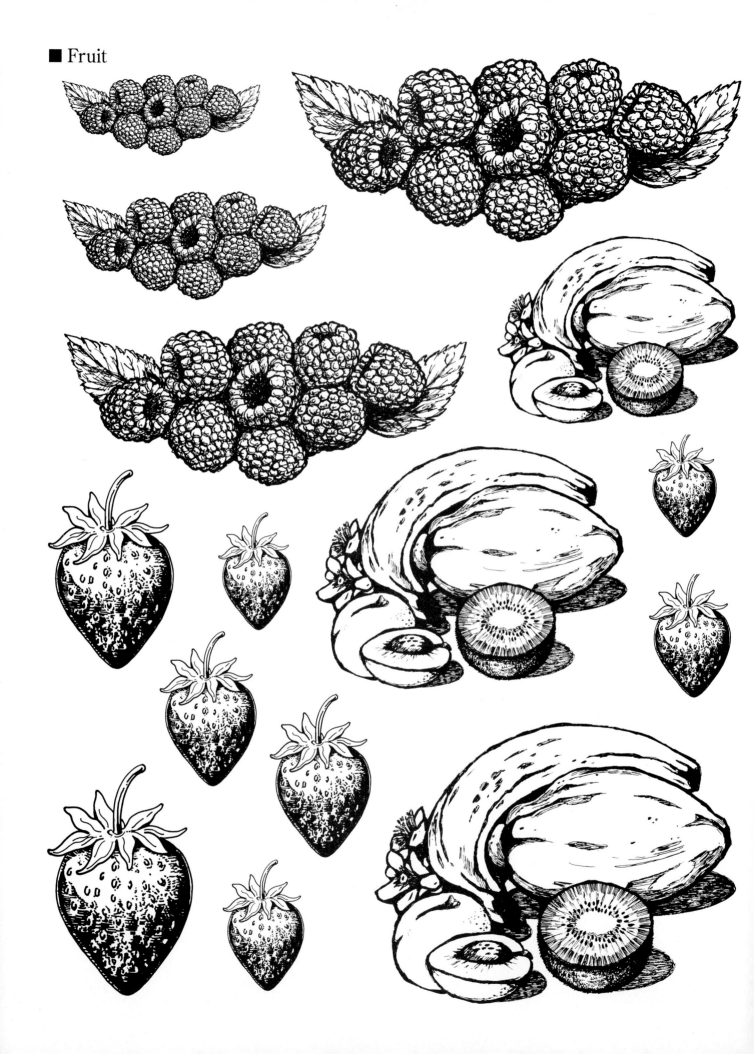

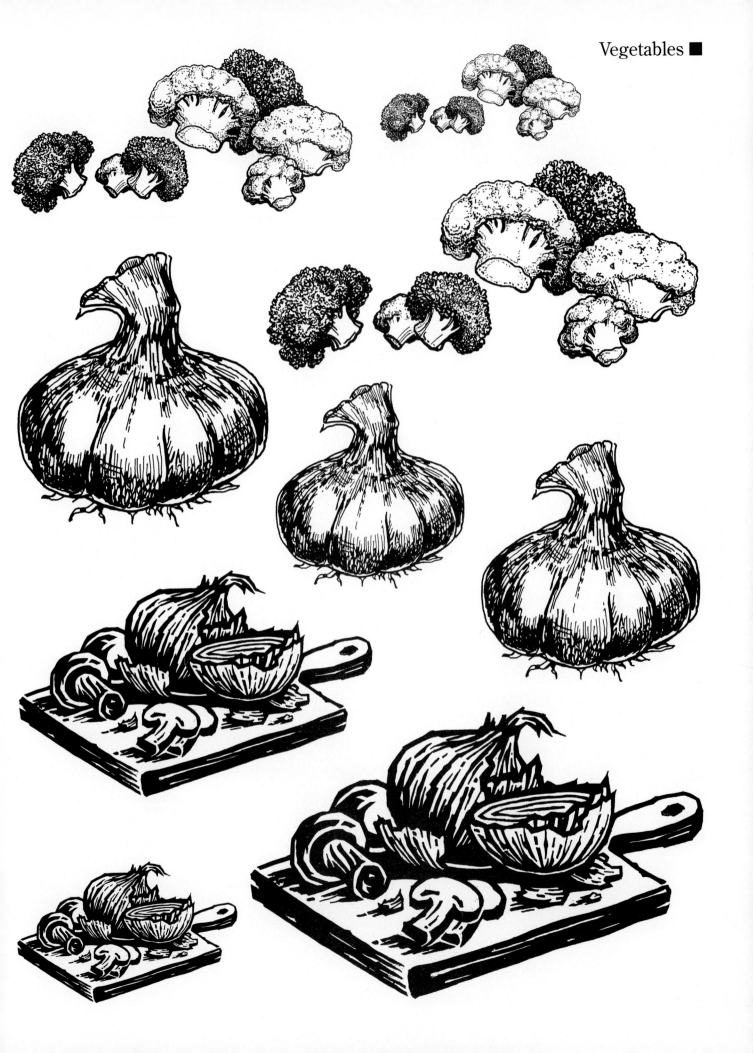

■ Vegetables

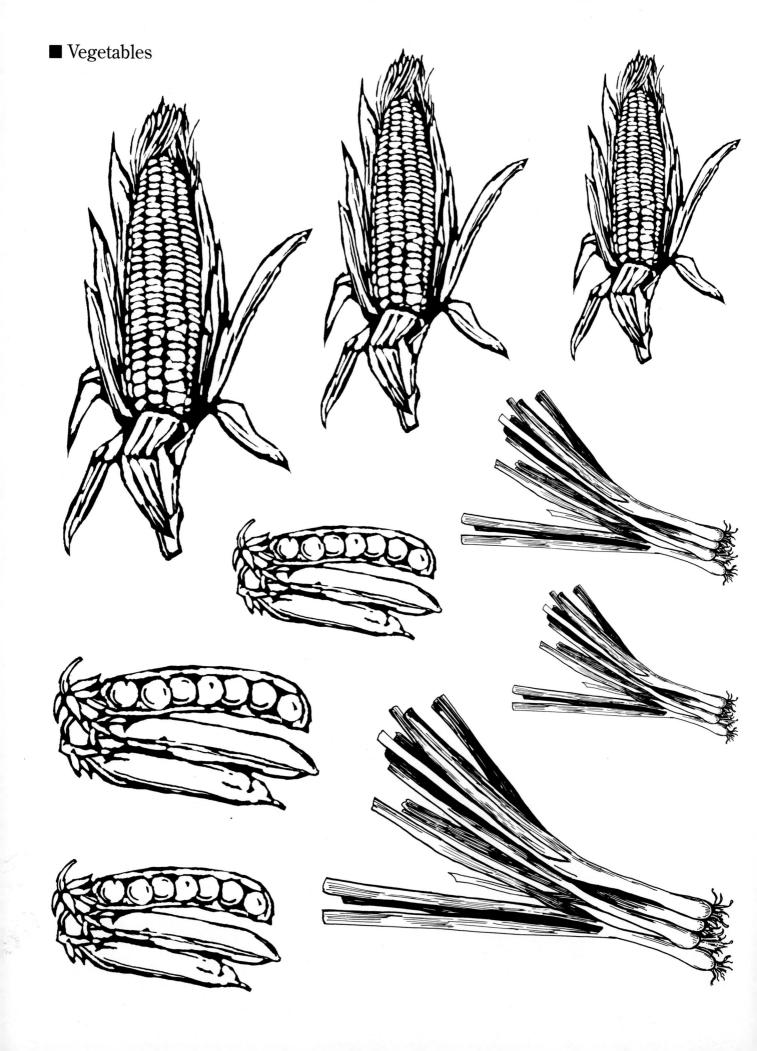

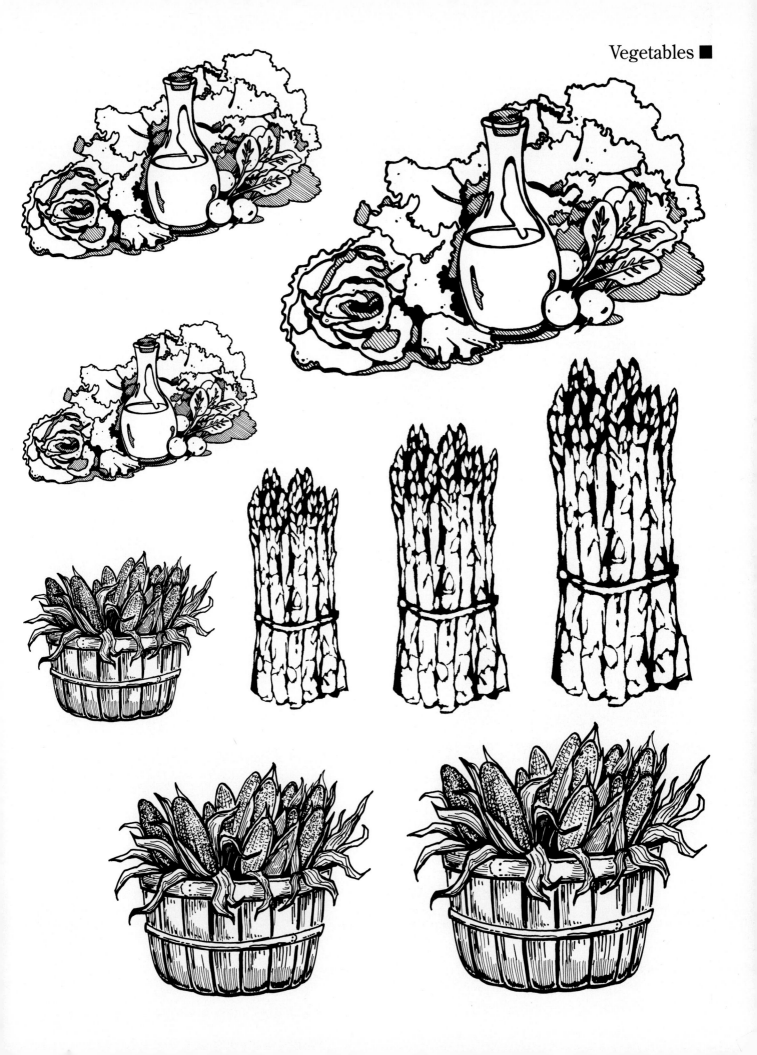

■ Vegetables

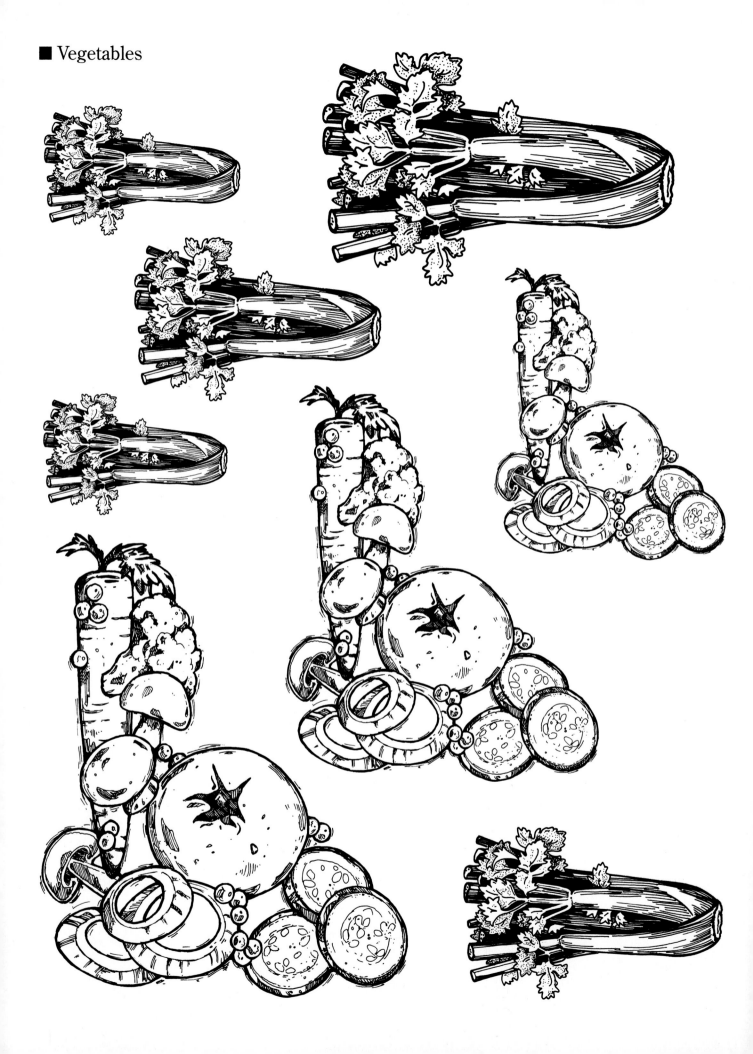

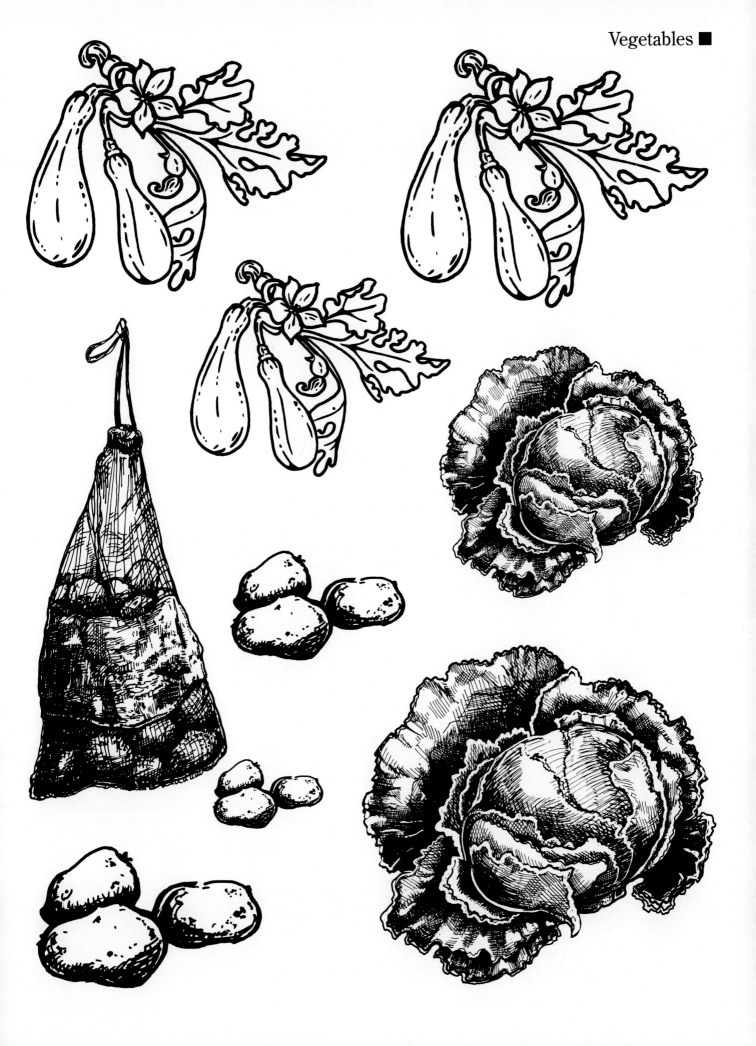

■ Vegetables

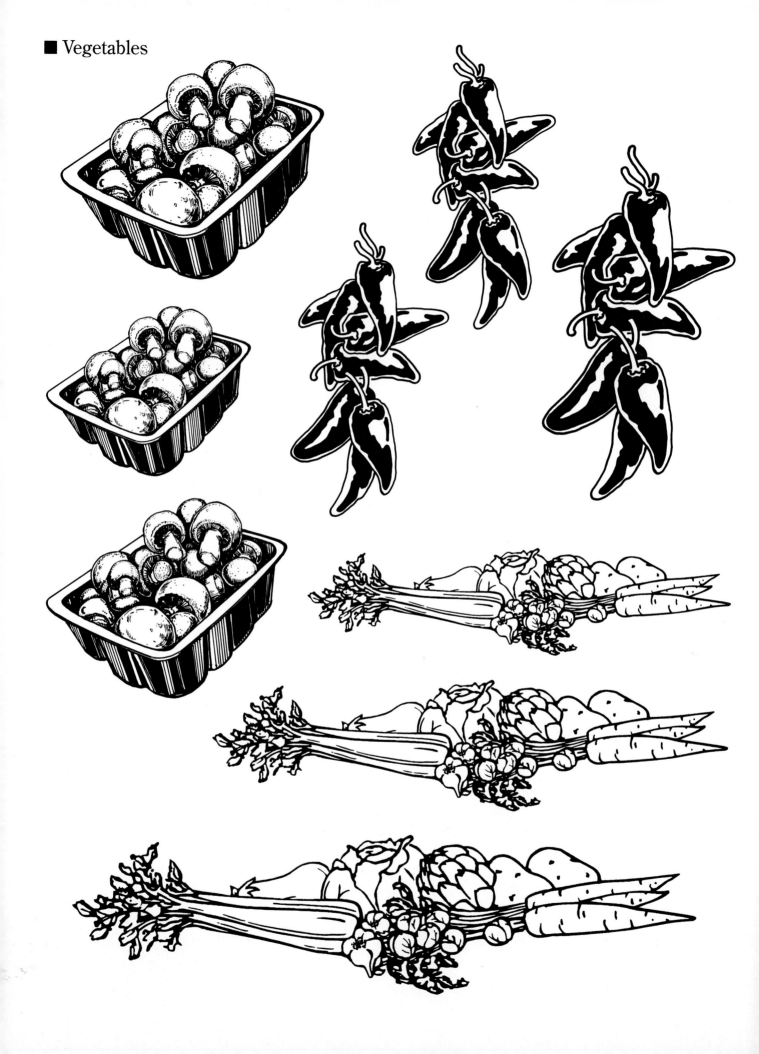

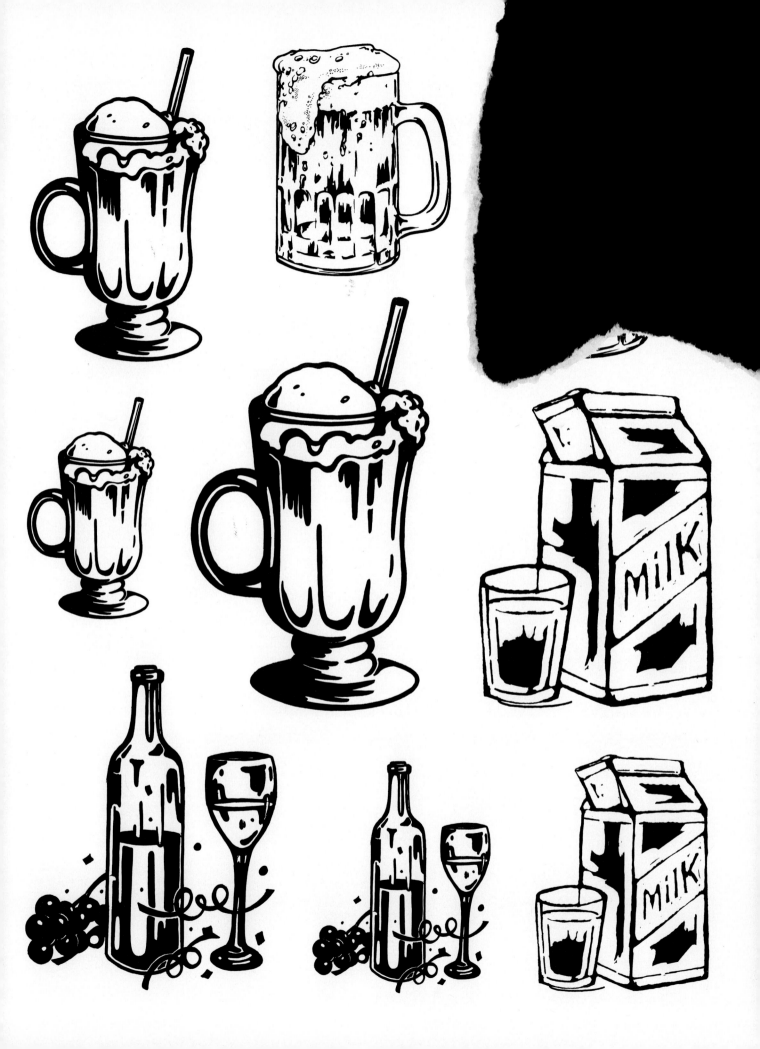

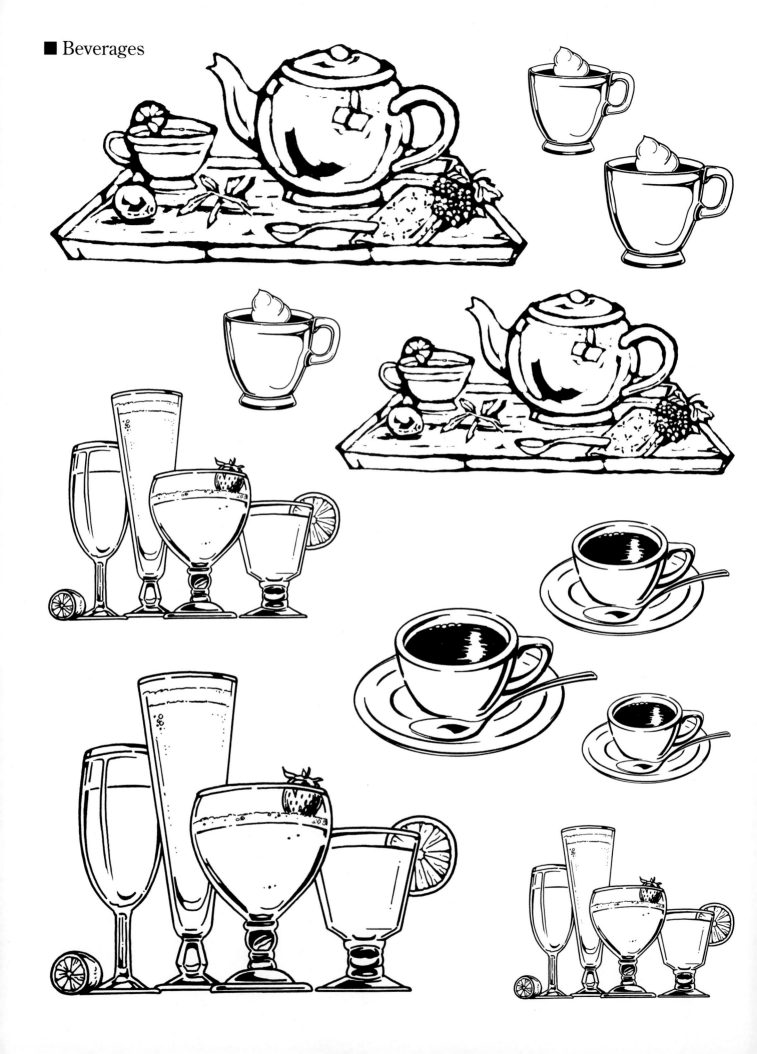

The Food Pyramid

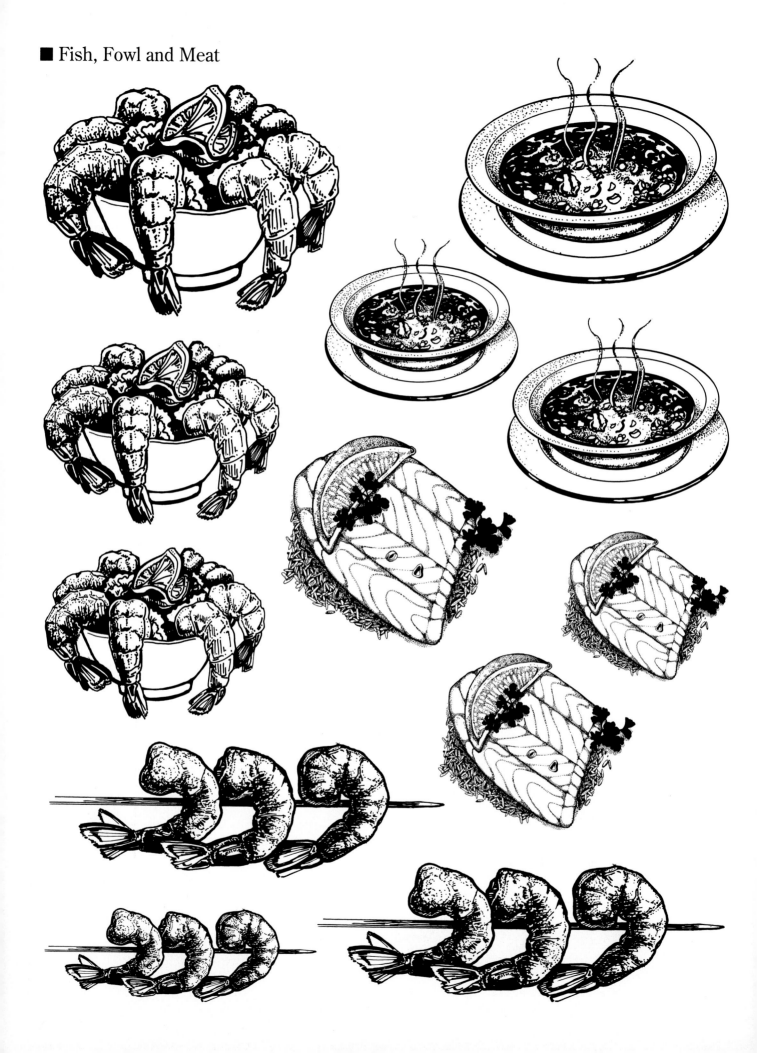

■ Fish, Fowl and Meat

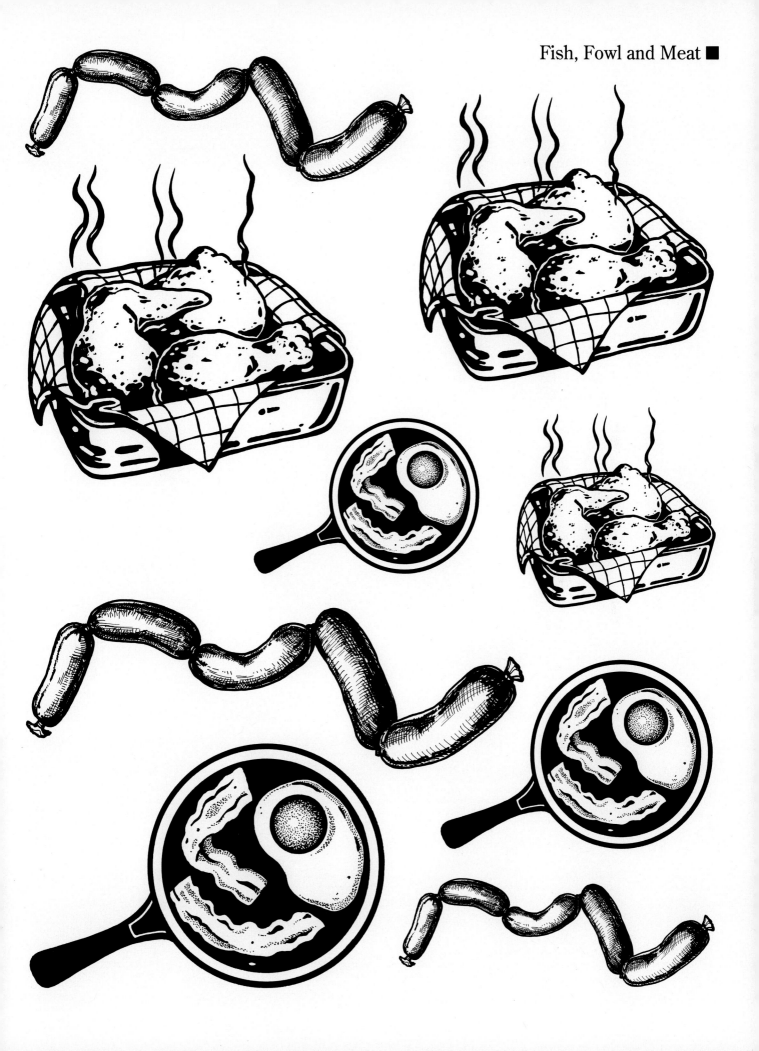

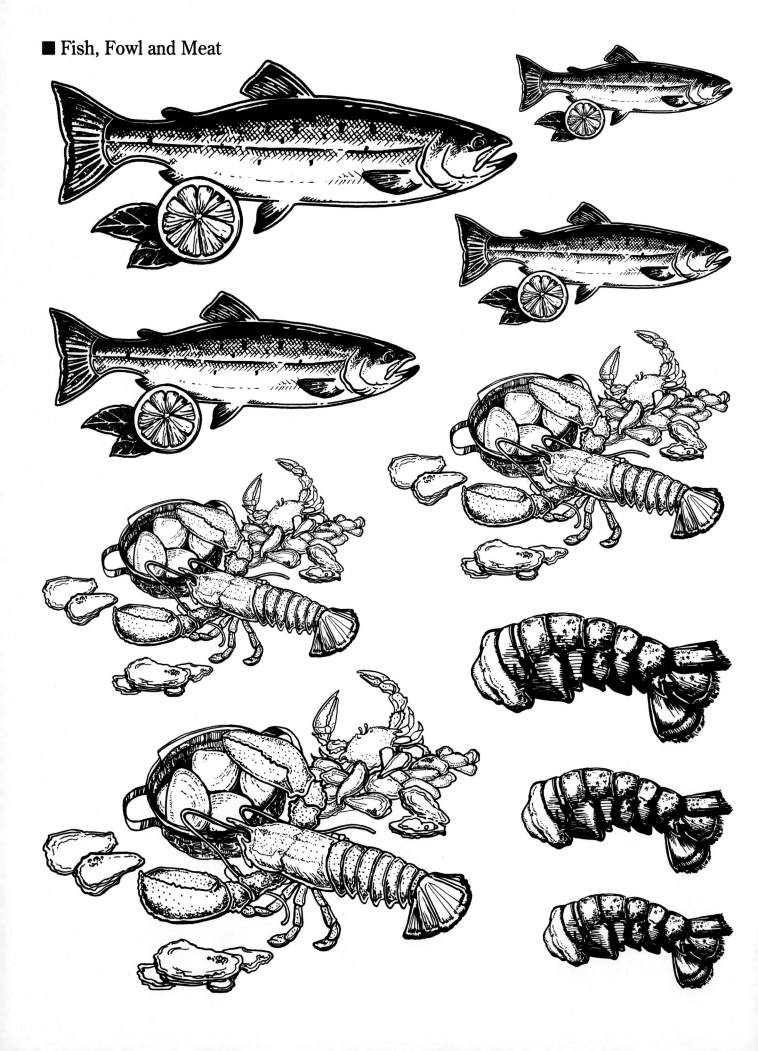

■ Fish, Fowl and Meat

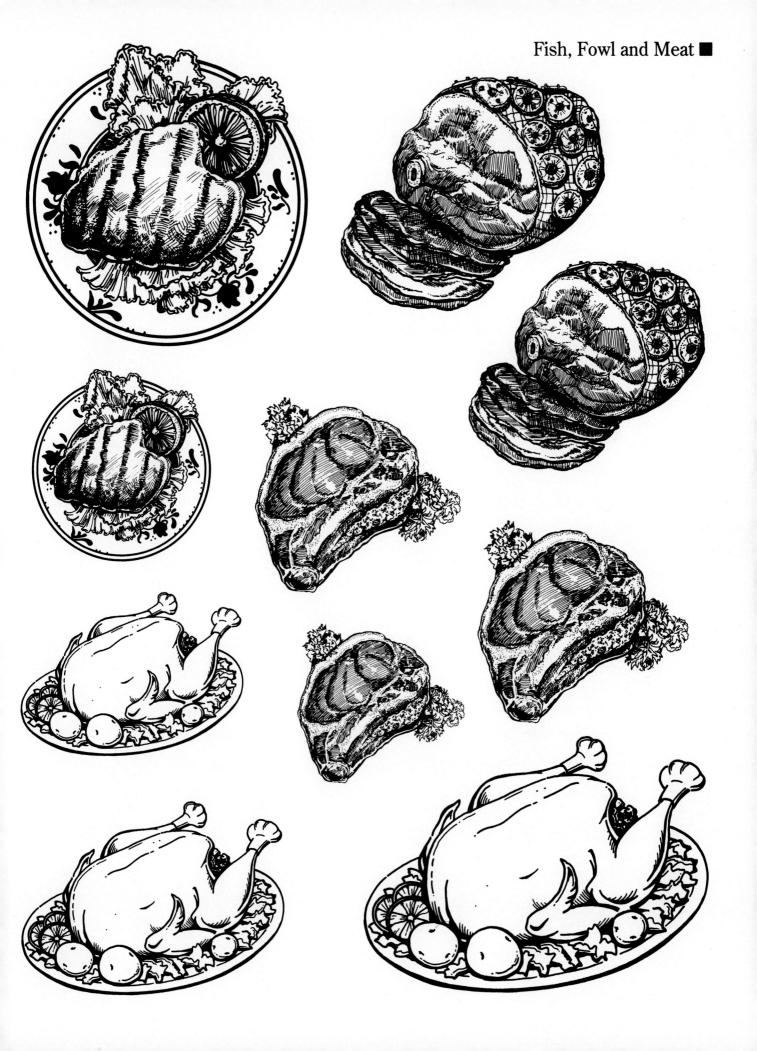

■ Fish, Fowl and Meat

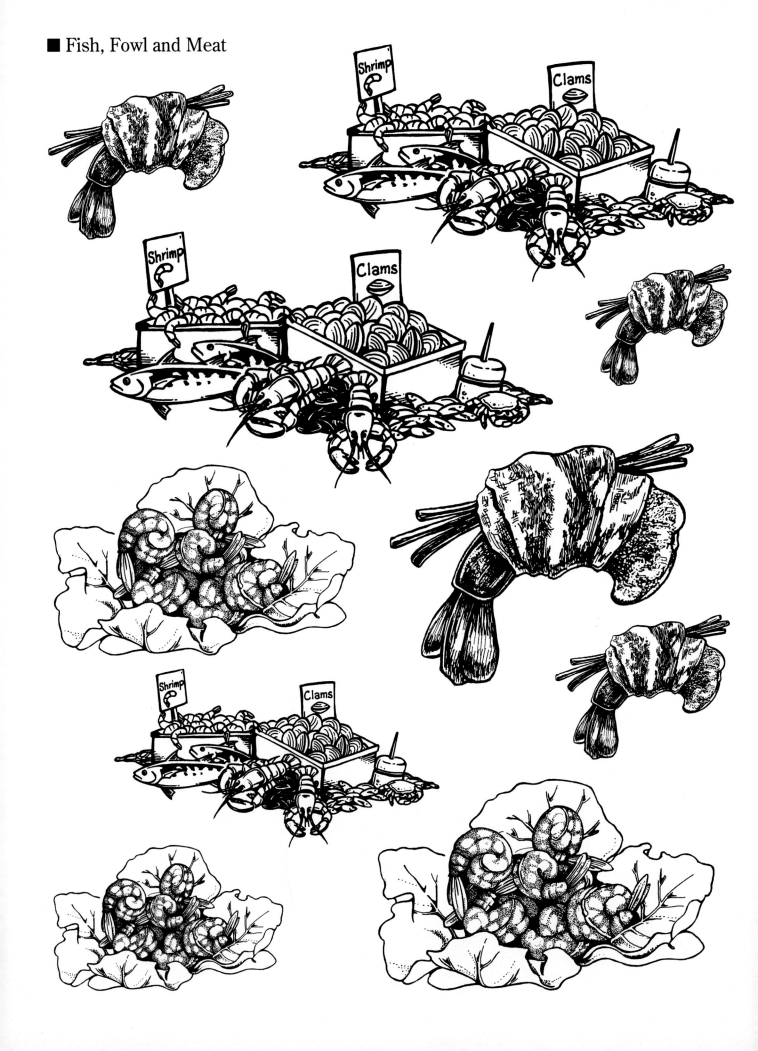

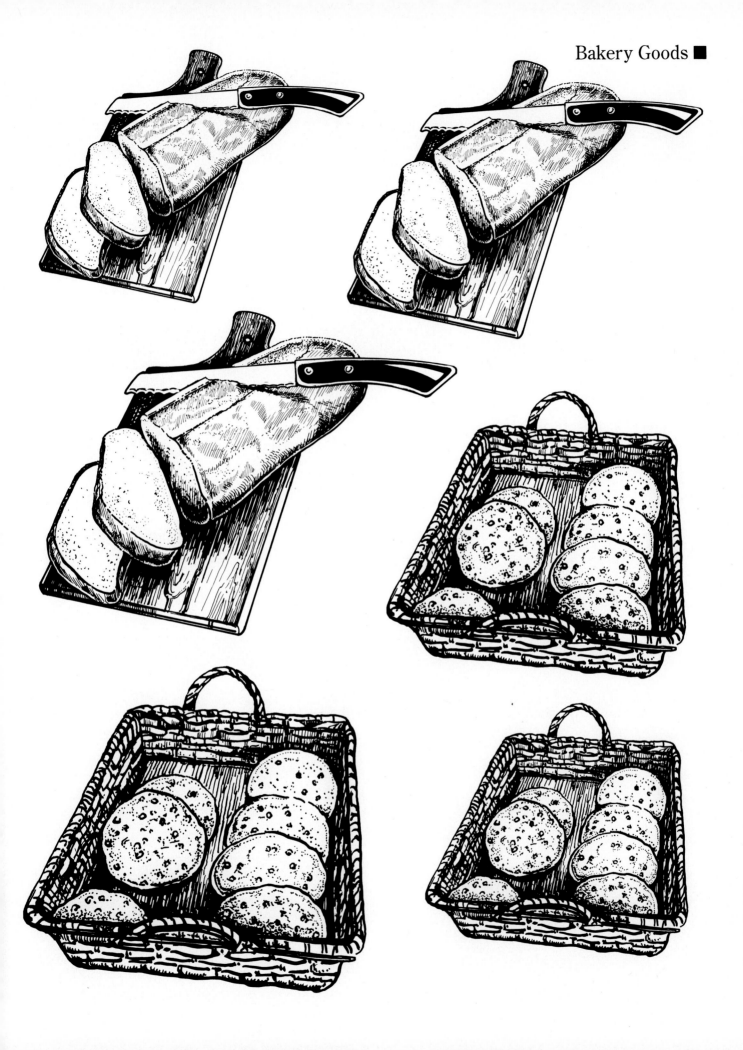

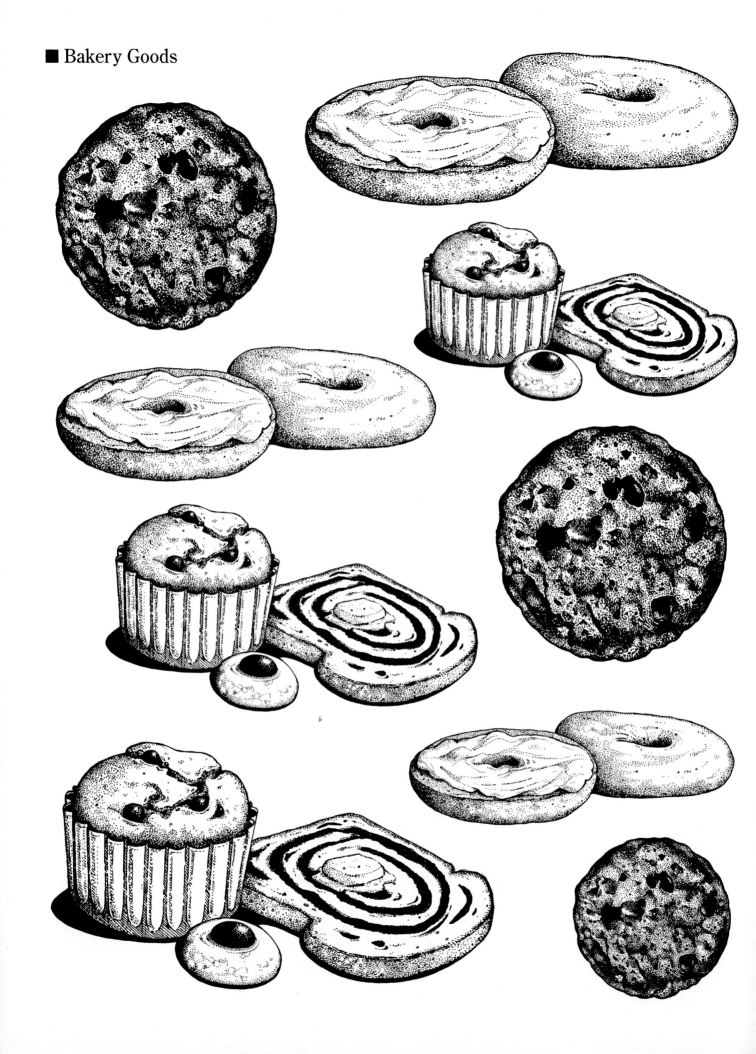

■ Bakery Goods

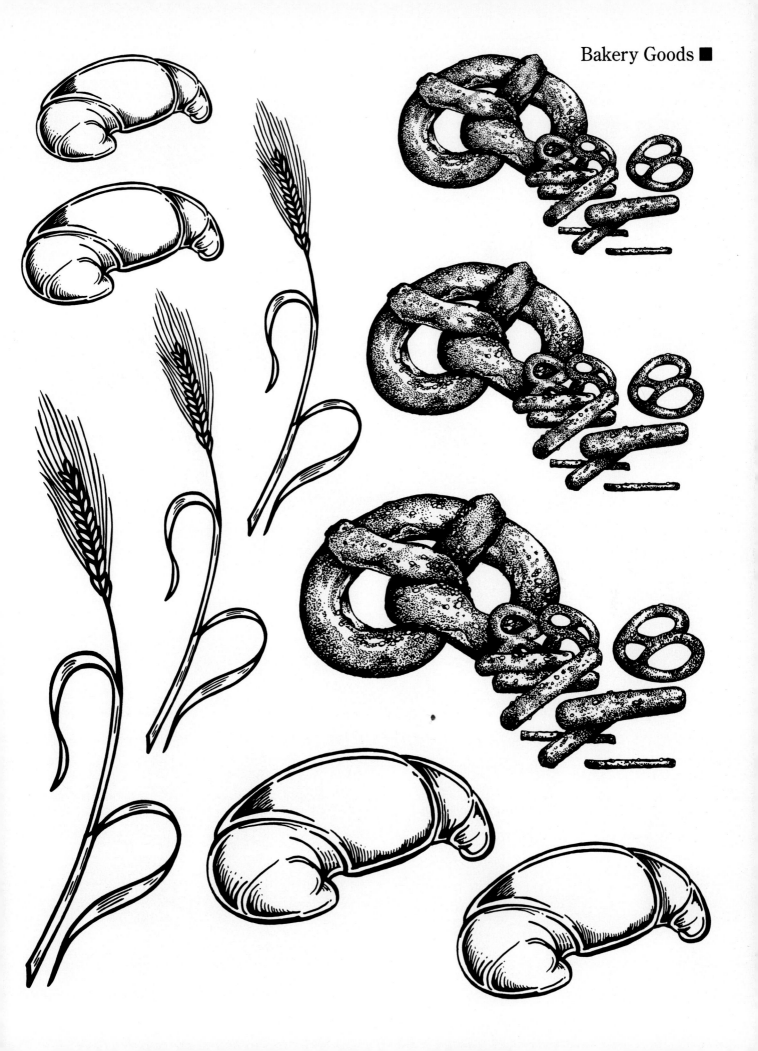

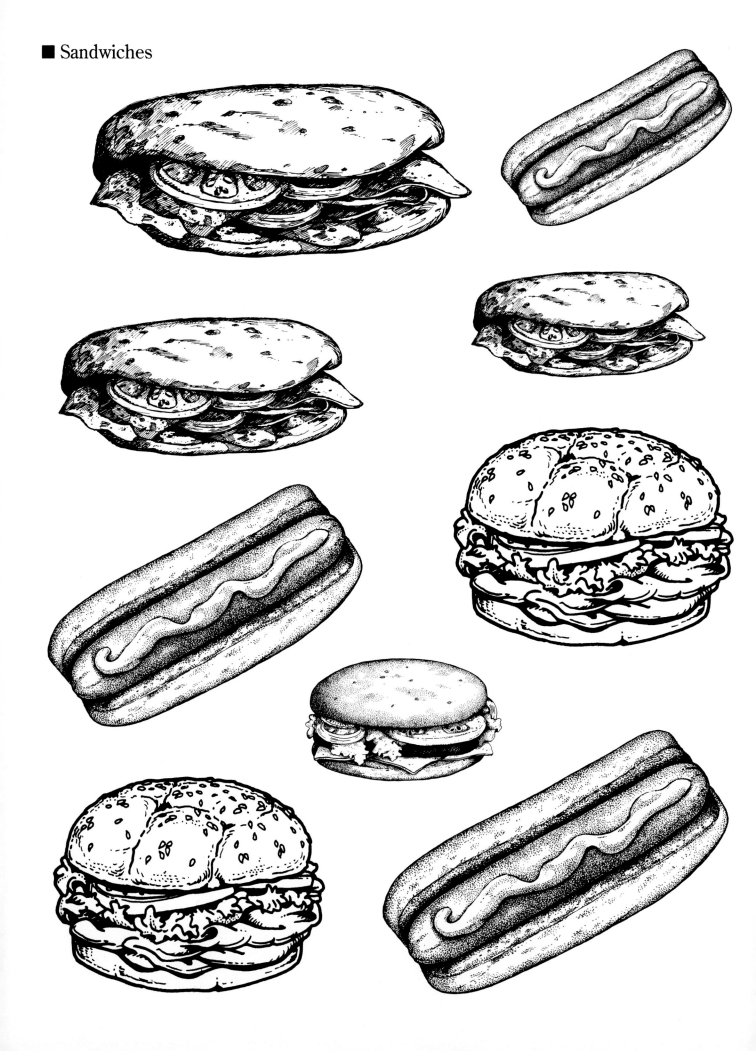

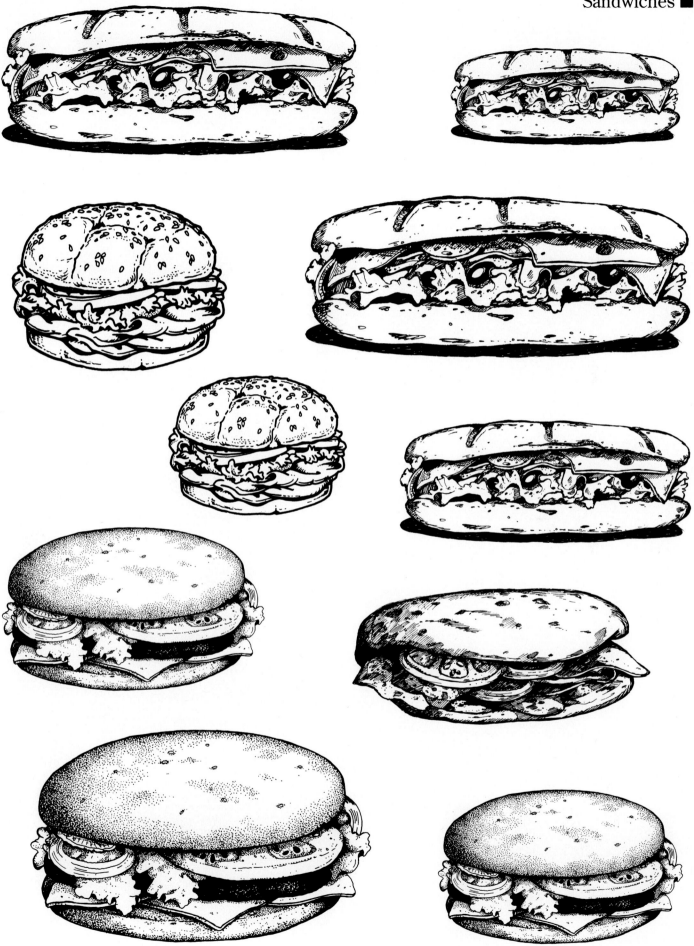

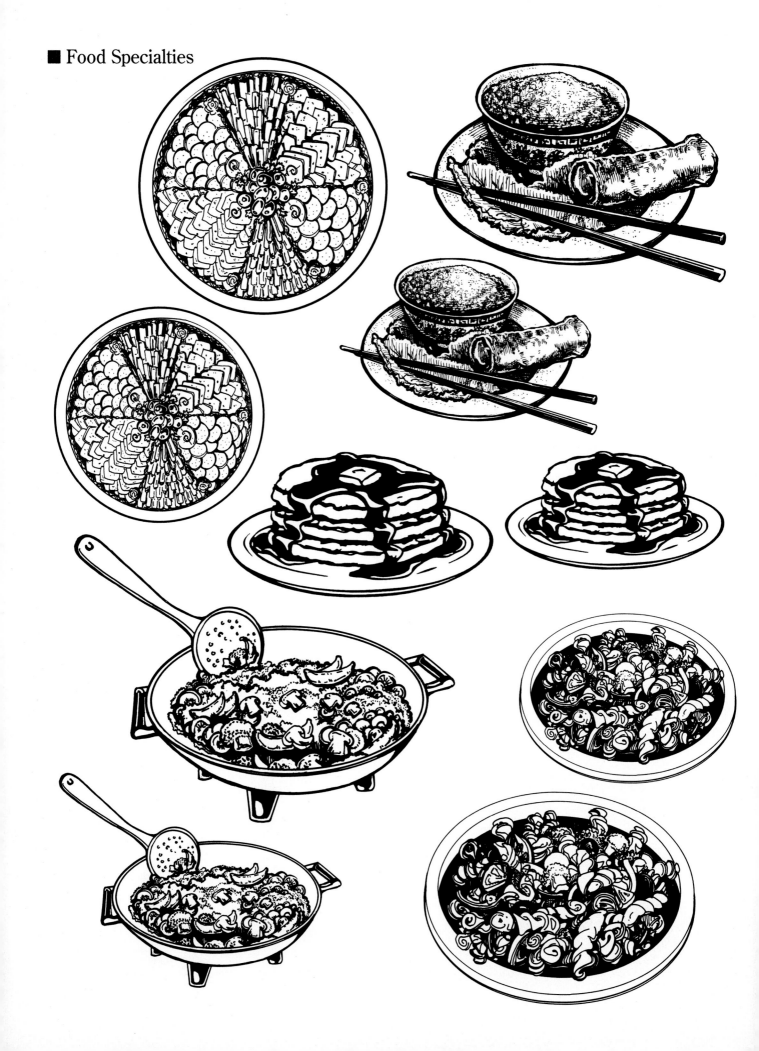

■ Food Specialties

■ Food Specialties